Crossing the Atlantic

Bill Miller

Page ii: High Romance: an evocative nighttime view of the *Paris* as she speeds across the Atlantic. Page iii: Pre-World War I interiors of liners were sumptuous, palatial, often fantasy-like. Page iv: Completed in 1927, the *Ile de France* was the first Atlantic liner to use Art Deco styles. Page viii: The grand age of Atlantic crossing—a painting of Manhattan's "Luxury Liner Row" in the 1930s by marine artist Don Stoltenberg.

Photos pages 1 through 23 courtesy of Bill Miller

Text pages 1 through 7, 24 through 30, and 46 through 50 © MMVII by John Maxtone-Graham

Text pages 9 through 23 © MMVII by Bill Miller

Compilation © MMVII by Graphic Arts Books

For additional photo credits see page 72.

All rights reserved. No part of this book may be reproduced or transmitted in any form or by any means, electronic or mechanical, including photocopying, recording, or by any information storage and retrieval system, without written permission of the publisher.

Library of Congress Cataloging-in-Publication Data

Miller, Bill, 1948-
 Crossing the Atlantic / by Bill Miller ; preface by John Maxtone-Graham.
 p. cm.
 ISBN 978-0-88240-661-9 (softbound)
 1. Cruise ships. 2. Ocean liners. I. Title.
 VM381.M444 2007
 387.5'4209163—dc22
 2007003934

Graphic Arts Books
An imprint of Graphic Arts Center Publishing
P.O. Box 10306, Portland, Oregon 97296-0306
503/226-2402
www.gacpc.com

President: Charles M. Hopkins
Associate Publisher: Douglas A. Pfeiffer
Editorial Staff: Timothy W. Frew, Kathy Howard, Jean Andrews,
 Jean Bond-Slaughter
Production Coordinator: Vicki Knapton
Designer: Brad Greene
Cartographer: Gary J. Antonetti, Ortelius Design, Inc.

Printed in China

Crossing the Atlantic

Cie Gle TRANSATLANTIQUE
FRENCH LINE

PARIS

Paquebot "Paris"
HAVRE — NEW YORK

CONTENTS

Map ...vi

Preface by John Maxtone-Graham ...1

Introduction by Bill Miller ...9

The Northern Route ...24

The Southern Route ...47

THE ATLANTIC DESTINATIONS

GREENLAND
- Nuuk
- Qaqortoq
- Cape Farewell

CANADA
- St. Anthony
- Corner Brook
- Cape Breton Island
- Newfoundland and Labrador
- St. Johns
- Halifax
- Nova Scotia
- Bar Harbor
- Boston
- Newport
- New York

UNITED STATES
- Cape Canaveral
- Ft. Lauderdale
- Miami
- Key West

BAHAMAS
- Nassau

Bermuda

Atlantic Ocean

DOMINICAN REPUBLIC
- La Romana
- San Juan
- Puerto Rico
- St.-Martin/St. Maarten
- Guadeloupe
- Martinique
- Barbados
- Grenada

Caribbean Sea

CROSSING THE ATLANTIC

PREFACE

by John Maxtone-Graham

I must have crossed the Atlantic two hundred times, legacy of a Scottish–American heritage as well as my career as a lecturing maritime historian. My first was aboard *Minnewaska* in 1930 at the age of six months; these days, I complete at least a dozen annually, and every one of them remains equally compelling.

The ancient term *liner* indicated the vessel's employment: liners made line voyages, uninterrupted passage from New York to Southampton, Hamburg to Boston, Genoa to Baltimore, and the reverse. Steaming for purpose rather than pleasure, they sailed year-round through unpredictable waters on occasionally bruising schedules.

Shipping companies designed and launched increasingly ambitious vessels—bigger, faster, or grander than their competitors'. But grandeur alone did not dictate their unprecedented tonnage. They were huge because millions of Europe's dispossessed clamored for cheap, westbound passage. Accommodated uncomplaining in dormitories buried deep within the hull, emigrants were the companies' most profitable passengers.

For cabin shipmates housed above, early crossings offered little entertainment save alternate evenings of bingo and horse racing. The Atlantic Conference, a self-governing body to which all lines belonged, forbade paid entertainment; chorus lines and production shows did not exist, only occasional films. So passengers amused themselves with treasure or scavenger hunts, games, quizzes, masquerades and deck sports, perpetuating vibrant, homegrown entertainment. There was, in addition, dancing, drinking and, most important, conversation. Fellow passengers confined onboard for no more than a week established instant, sometimes lifelong friendships.

Perhaps the most misleading descriptive characterizing North Atlantic vessels was the clichéd alliteration "luxury

↑ In Europe, great posters stressed the convenient link between trains to the ports and then connecting to a liner for a crossing.

liner." With cabins less spacious than hotel rooms and catering remote from fresh markets, liners were scarcely luxurious. But they were immensely comfortable, burnished by the ministrations of dedicated crewmen and women. Stewards and stewardesses, of the same nationality as the owning company, were unfailingly concerned and efficient. Since Americans tipped best, they were always spoiled by stewards who had known them for years. Devoted recidivists with their ships of choice, Americans booked the same vessels and sometimes the same cabins summer after summer.

Then, in mid-twentieth century, the Wright brothers' invention abrogated the transatlantic equation as crossing time was reckoned in hours rather than days. Predictably, the jets trounced the liners, and those traditional carriers gradually disappeared. But nowadays, thanks to the burgeoning popularity of cruising, crossings are commonplace again because of changing seasonal markets. Vessels wintering in the Caribbean cross to Europe's Mediterranean or Baltic for summer deployment, flocking like migratory birds eastbound in the spring and returning westbound in the fall.

Those repositioning crossings remain one of today's irreplaceable travel bonuses. Unpopular at first, they were

◆◆ An Anchor Line Poster encouraged British passengers to cross the Atlantic and visit America. ◆ The ivory-colored phone was a symbol of the high indulgence of ocean liner travel. First-class passengers could simply phone for just about any need. ◆ The splendid first-class lounge aboard the *Majestic* in the 1920s. ◆ White Star Line's 56,000-ton *Majestic* was not only the biggest steam liner in the world in the 1920s, but the largest ship of any kind.

CROSSING THE ATLANTIC 3

marketed cheaply. But wise passengers, surfeited with ports, have realized that, though no longer a bargain, crossings remain superior to the aimless circularity of a cruise.

To be candid, cruising is essentially frivolous. Initial embarkation is followed by a series of exotic calls and concludes with return to the port of origin; no geographical destination has been achieved whatsoever. But a crossing predicates a decisive change of locus, abandonment of one hemisphere and one continent for another as the vessel, its crew and its passengers set off on a blissful, maritime quest. There is no more exciting shipboard notice than a Madeira gangway advisory: "The vessel departs this evening for St. Thomas," thousands of nautical miles away. Anchors will remain tethered

✦ The first-class dining room aboard the *France* of 1912 included a grand staircase as an entrance. ✦ White Star's *Britannic* ran between London and New York beginning in 1930.

CROSSING THE ATLANTIC

in hawse pipes and tenders in davits as relentless engine tremor predominates around the clock and a broad white wake unspools behind us. Ships are sea creatures, happiest under way rather than moldering in port.

Though transatlantic passage can be rough in any season, by way of compensation, those temporary seaborne communities revel in an enviable aura of incomparable food, memorable music, and exquisite service. Coupled with today's bountiful shipboard entertainment are the same evocative holdovers from the past, a fondly remembered legacy of heaving bows, chattering wood paneling, the genteel scrape of string orchestras, and the wondrous lure of an oncoming if changeless horizon.

✦ **Artist Don Stoltenberg's stylized version of Italy's champion liner, the *Rex*. The *Rex* and *Conte di Savoia* were the two flagships of Italia—Societa per Azioni di Navigazione, an amalgamation of three Italian shipping companies in the 1920s.** ➔ **Pre-World War I interiors of liners were sumptuous, palatial, often fantasy-like.**

CROSSING THE ATLANTIC 5

A frequently prescribed Victorian specific was the tonic effect of a sea voyage, and the same beneficial formula persists. Sea days enchant and crossings have coalesced into an almost perfectly choreographed transatlantic ritual. One unpacks, explores the vessel, makes new friends, avoids bores, observes departure, and succumbs to the unalloyed, seductive delights of the voyage.

Sea air is paradoxically bracing and soporific, encouraging the sedentary into brisk activity. Of a morning, dozens of passengers tramp around promenade decks with unflagging ambition, flock into gymnasia and either submerge within pools or poach themselves in hot tubs. Hallowed shipboard institution is a mid-morning cup of bouillon or, in that longer gap separating lunch from dinner, tea, sandwiches, or pastry every mid-afternoon. But regardless, mid-ocean torpor lurks and the lure of a deck chair or cabin siesta proves irresistible. Ship's officers learned that lesson long ago; passengers in search of master or purser, *maitre d'hotel* or housekeeper, will never find them between two and four P.M.; all have succumbed to a restorative, postprandial nap.

Years ago, Royal Viking ships replaced elevator carpets daily: *Today is Thursday*, they announced. Small wonder, for successive sea days blur into seductive anonymity; few know—or care—what day of the week it is at all.

◆◆ Companies such as Cadbury featured great liners on their candy and cookie tins. ◆ The indoor pool aboard the French flagship *Normandie* was eight feet of graduated, tiled levels. One of the most luxurious liners of its day, the *Normandie* made its maiden voyage in 1935. ◆ Choice keepsake, prized souvenir: a cigarette case from the White Star Line. ◆◆ Today's cherished memorabilia: a 1930s cookie tin commemorating the then new *Queen Mary*.

6 CROSSING THE ATLANTIC

Perhaps best of all is each evening's festivity as passengers withdraw indoors. There is no more exhilarating spectacle than a ship's dining room in mid-ocean. Stewards and passengers are dressed in their best, candles glow, and an animated buzz of conversation and music enriches every languid course.

Then, a new continent appears and a pilot embarks. The crossing has ended, the fairy tale concluded. Every cabin diaspora is regretfully dismantled, suitcases stuffed, and addresses exchanged. Mid-ocean indolence is superseded by immigration and customs formalities.

But, remember, there will always be crossings and, like our American forebears, the same ships, the same cabins, and even favored fellow passengers may be encountered time and time again.

CROSSING THE ATLANTIC 7

CROSSING THE ATLANTIC

INTRODUCTION
by Bill Miller

We recall them from Hollywood movies—with the likes of Fred and Ginger, glamorously clad, crossing the Atlantic Ocean on highly stylized, over-decorated liners. The whistles sounded, Fred sang, Ginger swooned, and even the colorfully dressed crewmembers tapped out a few steps. Then there was Lucy, missing the *Constitution* as it left Manhattan for Europe, in one of the classic episodes of her 1950s television series. Then there were also the likes of *An Affair to Remember* and *A Night to Remember* and, of course, the very recent *Titanic*. Often, sailing the Atlantic by liner has been pure, rich nostalgia. Regrettably, over the past two or three decades, crossing the Atlantic by luxury ocean liner seemed to have all but vanished—except, of course, for the current six-day runs between New York and Southampton aboard Cunard's 2,600-bed *Queen Mary 2*, a 150,000 tonner and one of the largest liners built to date.

But these days, however, Atlantic crossings have become regular features on many cruise line schedules. Ships of all sizes shift in spring, for example, to Europe, spend the summer season there and then return, going westbound, in the fall. They often sail to and from some of Europe's most famous cities: London, Amsterdam, and Copenhagen as well as, on more southern passages, Rome, Barcelona, and Lisbon. Recently, my wife and I took an early autumn crossing—sixteen days from Civitavecchia (Rome) to New York with eight ports of call along the way: Livorno (for Florence), Monte Carlo, Barcelona, Valencia, Cadiz, then Horta and Ponta Delgada (in the Azores), and finally Bermuda. Even the finish was a great attraction: arriving to the early morning colors, lights, and cityscape of New York harbor. We had, of course, the expected excursions at the ports of call: touring the cathedral and other historic highlights in magical Florence, jet-skiing at chic Monte Carlo, helicoptering over booming Barcelona, wine tasting in the

✦ **With the emergence of ocean travel Europe became more and more inviting to more and more Americans.** ✦ **Screen goddess Rita Hayworth, seen here in 1955, was among the legions of celebrities that sailed the Atlantic.**

Azores, and a bus tour of "famous homes" on Bermuda. But to many, and including myself, it was the seven sea days in the mid-Atlantic that had the greater appeal. "Sea days says it all," commented one Los Angeles–based passenger. "They are so leisurely. And this trip is just about the perfect combination of sea days and ports of call. The ports are interesting, fascinating glimpses of romantic and often historic places, but the sea days allow you to do whatever you like—from a lecture to a movie to a cooking class to eating gourmet meals or to just spending time in a deck chair with that good book. And this cruise even had an added bonus. It was a Big Band Theme Cruise and each night we had the sounds of Glenn Miller and Benny Goodman. It doesn't get much better!"

◆ Back to business in the 1950s and 1960s—not less than nine passenger liners berthed together on a summer's day along New York's "Luxury Liner Row." ◆◆ The *Queen Mary* boasted fifty-six different types of wood in the decoration of its grand interiors. Along with its slightly larger sister *Queen Elizabeth*, the *Queen Mary* was the first of Cunard's planned two-ship weekly express service from Southampton to New York. ◆ Marlene Dietrich departs for Europe with no less than thirty trunks and cases in 1937.

Crossings: A Short History

Images and memories of great liners, such as the *Queen Mary* and the *Normandie*, making crossings often began at the New York City piers, in an area along the West Side that was aptly called "Luxury Liner Row." Ten Atlantic liners might be in port in a single day. And in those days long passed, passengers and visitors would board the liners three hours before actual sailing time. There were champagne parties, dance bands, reporters following film stars and royalty, lots of those big, bulky trunks and oversized bouquets of flowers, and cellophane-covered

CROSSING THE ATLANTIC

↑ The *Normandie's* first-class dining room sat one thousand passengers at four hundred tables. ↓ Even dogs lived well on the Atlantic liners as evidenced by miniature New York City fire hydrants aboard ships such as the *Normandie*. → Half of the ship's twelve hundred crew members posed in this bow section photo aboard the *Normandie*.

baskets of fruit delivered to staterooms by impeccably uniformed stewards. Then, a thunderous whistle sounded and a message was delivered: "All ashore that's going ashore!" The ship would sail in thirty minutes.

Tiny tugs would ease these great liners into the Hudson River as well-wishers, thousands strong, waved from the pier's upper deck. Suddenly, with those long, multicolored, paper streamers as the final link, the ship became a floating city—a world unto itself. Passing the great Manhattan skyline and then the Statue of Liberty, the ship moved out to sea, to the vast and open Atlantic. Days of leisure, fun, relaxation, pampering, even adventure and romance were ahead. Passengers settled into their stateroom, making dining room reservations and selecting a reserved, cushioned deck chair along the upper decks or promenade.

The great liners provided a luxurious sense of well-being, created by the most gracious, thoughtful service. The glass-enclosed Promenade Deck, for example, within sight and sound of the sea, was just one of many onboard places that offered relaxation, a glorious sense of peace and serenity. A steward always seemed to be at hand, however. Here comes the mid-morning cup of bouillon! And how refreshing it tastes with the smell of the brisk salt sea air!

First-class travelers sometimes brought their own servants along and sometimes even the likes of their own linen, china, and personal effects to enhance and personalize suites and

CROSSING THE ATLANTIC

staterooms. They had private trunk rooms, pets in the kennels and, quite often, a big American car in the ship's hold. Some took their meals only in the confines of spacious quarters and some even had their own cook in tow. They were prized guests, treated to the very finest service and with the greatest consideration. One American tycoon booked the same suite on the same ship for ten years so as never to be disappointed. Another spent $100 a day on fresh flowers. One heiress always brought along some furniture—reminders of home! Even in later years, grand travel lingered. In the 1950s and '60s, the likes of the Duke and Duchess of Windsor traveled only by liner and with never less than ninety-eight pieces of luggage including at least thirty of those big Vuitton trunks.

Cabin or second class was aptly dubbed "the happy medium"—it lacked the high formality of first class and the informality of tourist class. Inexpensive tourist or third class often meant sharing a berth in a lower-deck cabin for four or six. Shower and toilet were, of course, down the hall.

Dining aboard these great maritime behemoths was always a delightful, memorable experience, "an occasion" whether it be breakfast, lunch, afternoon tea, dinner, that midnight snack. The onboard chefs, confectioners, and bakers were among the top culinary masters in the world. Each menu offered a wide and wonderful choice of delicacies, and the wine list, a small book in itself, provided a variety of superb vintages to

CROSSING THE ATLANTIC

complement each and every course. In the late 1930s, onboard the French *Normandie*, a dinner in first class included seven items for hors d'oeuvre, five soups, pike in butter sauce and fillets of turbot for the fish course, braised sweetbreads for an entree, a special French recipe for Duckling a l'Orange, three vegetables, five kinds of potato, four pastas, two roasts, nine items from the cold buffet, six salad choices, six cheeses, two French pastries, three puddings, five flavors of ice cream, two fresh fruits, two wines (which were free of charge on all French liners), and finally assorted coffees and teas.

And even the dogs ate well. The *Normandie*'s pet brochure noted, "Meals are served at eleven in the morning and five in the afternoon. Unless passengers request special 'dishes,' meals

14 CROSSING THE ATLANTIC

◆ **A baggage tag from the *Leviathan* of the United States Lines.** ✦ **The size of these maritime leviathans fascinated the public. This illustration places the twin-screw express mail steamer *Kronprinzessin Cecilie* on St. Peter's Square in Rome.** ✦✦ **The German super liners had sumptuous, castle-like interiors.**

are chosen from the regular printed pet menu. Everything is served to M'Doggie, of course, on monogrammed, porcelain plates and cups."

Entertainment in days past included afternoon bingo and even sessions of horse racing, a major film in the ship's theater or perhaps a fancy hat contest after dinner. On smaller passenger ships, a quiz in the lounge or dancing to recorded music might suffice. And before dinner, on the bigger ships, there might be a swim in the lavish saltwater pool or time in a Turkish bath, a set on the squash courts or a turn in the fully equipped gymnasium. The bigger liners also offered gift shops, hair salons, banking and travel facilities, and, conveniently, ship-to-shore telegraph and telephone services.

It was, of course, all very formal. "As ladies in first class, we had three changes of clothes each day—morning clothes, tea clothes and formal wear for dinner," remembers Kitty Carlisle Hart, who has crossed the Atlantic over one hundred times beginning in 1929. "Women passengers had a much more difficult time—they could never, ever be seen in the same dress twice on shipboard. So, I would leave New York with three trunks. And one of them was just for shoes!"

Five, six, seven days—or even longer—to Europe would pass ever so quickly, or so it seemed. Suddenly, you were in London or Paris or Madrid. Indeed, it was the only way to cross.

Back in the 1850s, for example, wooden paddle-wheelers took two and three weeks to cross the Atlantic and offered travelers limited, often cramped and uncomfortable quarters. But by 1900, the Germans, for example, had created the first so-called "super liner," the 14,900-ton *Kaiser Wilhelm der Grosse*. She could carry 1,970 passengers in three classes—first class, second class, and steerage. Her first-class quarters were so sumptuous that they were said to remind guests of "castles on the Rhine." As technology rapidly advanced, so did the heated race between ship owners as well as the nations behind them. Less than a decade later, the Cunard Line had built the *Lusitania* and *Mauretania*, which were faster, grander, and more than double the size. The public was bedazzled, it seemed, by their statistics, size, pure might—and certainly their fantastical interiors. Onboard the 787-foot-long *Lusitania*, for example, the first-class restaurant was done in Louis XVI style and finished in white and gold. Her main lounge was done in Georgian and was capped by a great domed ceiling that included a stained glass skylight. There were several grand staircases as well as the novelty of two electric elevators. And all the bathroom fixtures in first class were silver plated.

But such distinction, innovation and, most of all, fierce competition only prompted bigger, faster, more lavish liners. The 46,000-ton *Titanic*, commissioned in 1912, was said to be the "world's first unsinkable liner" while the 54,000-ton,

CROSSING THE ATLANTIC

4,594-berth *Imperator*, German and in service a year later, was dubbed "the colossus of the Atlantic." And even bigger liners were on the drawing boards.

While much has been said and written about the opulence of the great liners, their main income came, in fact, from lower-deck third-class passengers, the infamous steerage. In the smallest, least comfortable, most under-ventilated spaces, immigrants left just about every part of Europe and paid up to $10 for a ticket to America. Escaping poverty and oppression, they believed that the streets were paved with gold in the United States. It was the promised land. So, business boomed and the steamship lines made fortunes. By 1907, immigrants in

◀◀▲ The main foyer aboard the French liner *Paris*, completed in 1921. The *Paris* served as the French postwar flagship until the christening of the *Ile de France* in 1927. ◀ The four-funnel *Mauretania*, commissioned in 1907, was one of the most beloved of all Atlantic luxury liners and the most famous of a new breed of liners to take to the seas at the start of the twentieth century. Her nearly identical sister ship, the *Lusitania*, was sunk by a German submarine in 1915. ◀▲ A poster offers service from New York to Bremen aboard Germany's Four Flyers: *Kaiser Wilhelm II*, *Kronprinzessin Cecilie*, *Kronprinz Wilhelm*, and *Kaiser Wilhelm der Grosse*. By 1900, Germany sailed the world's largest liners. ▲ The dining facilities in the lower-deck steerage of the *France* were a stark contrast to the opulent first-class dining room.

CROSSING THE ATLANTIC 17

steerage were arriving in New York harbor at the rate of twelve thousand per day. By 1913, on the eve of the First World War, the rate had tripled, up to 1.5 million a year. Almost all of them arrived in New York harbor and passed through Ellis Island. Altogether, between 1892 and 1924, over eighteen million people crossed the Atlantic by ship. It was the greatest movement of humanity in world history.

In the 1920s, after the war ended, much-reduced US immigration quotas all but eliminated steerage. Economical tourist class was invented to take its place and cater to the new age of budget tourists off on a tour of Europe. New York to London, a weeklong passage, was appealingly priced at $40 in 1925. There were new ships—such as the decoratively stunning *Ile de France* in 1927—and older ones, but under new names—such as the *Berengaria*, *Leviathan*, and *Majestic*.

The 1930s was the absolute highwater, the ultimate age for luxury, size, splendor, even fantasy, for the great Atlantic liners. This period produced some of the most wondrous of all liners.

There were Germany's *Bremen* and *Europa* (1929–30), then the London-homeported *Empress of Britain* (1931), and then a pair from the Italians, the *Rex* and *Conte di Savoia* (both 1932). But it was the French who produced a liner to pull out just about all stops—and take all records as well! Commissioned in 1935, the exquisite *Normandie* was the first liner not only to exceed one thousand feet in length, but also the first to weigh more than 80,000 tons. She was also, for a time, the fastest ship afloat. While she had a very sleek, eye-catching exterior topped by three giant smokestacks, it was her interiors that received the highest praises and drew the deepest sighs. The main dining room, for example, was unlike anything yet

➔➔ **In the age of industrial and mechanical superlative, the *Titanic*, shown being built in 1911, was said to be the world's first "unsinkable" ship.** ➔ **By 1907, immigrants from Europe were arriving in New York harbor at the rate of 12,000 a day.**

CROSSING THE ATLANTIC 19

seen at sea—a brilliant creation of bronze, hammered glass, and light fixtures of Lalique art glass. It sat one thousand diners and rose three decks in height. The Winter Garden, with its tropical plants and lush greenery, also included caged birds and spraying fountains. The main lounge was done in Dupas-designed glass panels. Each of her four hundred first-class suites and staterooms was decorated in a separate style.

While the Cunard Line responded with the *Queen Mary* and *Queen Elizabeth*, completed in 1936 and 1940 respectively, the tragedy of the Second World War destroyed many liners and, in its aftermath, left a changed Atlantic. During the wartime years, the liners were called to duty, often heroically delivering troops to even the remotest ports. Many were destroyed by military action, such as the *Bremen, Empress of Britain*, and *Rex*. The celebrated *Normandie* was a casualty of another kind—she burned at her New York pier and then capsized in February 1942. But the *Queens*, the gray-painted *Mary* and *Elizabeth*, were incredibly heroic. Refitted to carry over fifteen thousand troops (from about two thousand each in comfortable peacetime quarters), they sailed in high secrecy, at top speeds, happily evading enemy attack. In fact, in July 1943, the *Queen Mary* established the all-time record of any ship when, on a trooping voyage from New York to Scotland, she had 16,683 souls onboard.

When the war ended in 1945, shipping companies looked to restore and rebuild. A virtual armada of new liners appeared. The US-flag *Independence* was the first fully air-conditioned luxury liner yet built, Holland's *Ryndam* offered comfortable tourist class quarters for as little as $20 a day, and Italy's flagship, the *Andrea Doria*, had no less than five swimming pools. Later, the three-year-old *Doria* made headlines when she rolled over and dramatically sank following a mid-ocean collision with Sweden's *Stockholm*, in July 1956, and for the first time brought a major maritime tragedy into American living rooms in the age of black-and-white television news. But while advanced Yankee know-how produced the brilliant

← Troops crowd the deck of the *Queen Elizabeth*. After the outbreak of World War II the *Queen Elizabeth* and her sister ship the *Queen Mary* were converted to troop ships and often carried as many as 15,000 soldiers in a single voyage. ↓ American troops aboard the *Queen Mary*, on their way to the war in Europe. Both the *Queen Mary* and the *Queen Elizabeth* were painted gray for camouflage and were nicknamed the "Gray Ghosts." → Wartime: The *Normandie* (top), *Queen Mary*, and *Queen Elizabeth* awaiting their calls to duty at New York in March 1940.

United States, the fastest liner of all time, making over 39 knots on her maiden passage in 1952 (in a crossing just over three days) and even registering up to 43 knots during her sea trials weeks before, aircraft gradually began to take more and more passengers. But most decisively, after the first jets crossed in 1958, the fate of the Atlantic liners and the age of crossing seemed to be finished. Suddenly and mercilessly, the big liners became big dinosaurs. By 1963, the airlines had 95 percent of all transatlantic passengers. By the mid 1970s, the *Queen Mary*, *Queen Elizabeth*, *United States*, and even newer ships, such as the *Rotterdam*, *France*, and *Michelangelo*, were gone—outmoded, deficit-ridden, symbols of a bygone era—or made over as cruise ships for use in warmer, more placid seas. Only the *Queen Elizabeth 2*, completed in 1969, was left—looking after those last, nostalgic travelers who wanted to sail rather than fly. Or so it seemed.

These days, more voyagers are making crossings than at any time in the last four or five decades. "I think veteran cruisers have learned what ship aficionados have always known," commented a New York friend who has made dozens of voyages. "Days at sea are the best—and crossings allow the maximum number of them. But at the same time, crossings often offer unusual ports of call on interesting itineraries. Seasoned cruise travelers are intrigued by the likes of calling at Nuuk in Greenland, Ponta Delgada in the Azores or the Faroe

CROSSING THE ATLANTIC

Islands. And I think it is important to remember that many people are anxious to avoid flying these days, even if just one-way." Another friend, also a seasoned cruiser, added, "The current crossings are popular because of pure nostalgia. Some crossed the Atlantic on long-ago summer trips, others emigrated by sea and still others never did it. Some vividly remember 'seeing my mother off at the New York docks back in the 1950s.' Today, crossing the Atlantic on a cruise liner is close to classic sailing of yesteryear. It is reminiscent of times gone by. People can, in ways, relive a golden era. And I even noticed that everyone dresses on formal nights on these crossings." And a Florida friend added, "We crossed to and from Europe at least a dozen times by ship in the 1950s and 1960s. It was wonderful. But today's crossings on modern cruise liners are happily blended with far more conveniences—from lecturers to dance hosts to television news in your cabin and even to rock-climbing walls! These days, I make one of these crossings-on-a-cruise ship every year. There's nothing like them!"

Ports of Call

I've crossed the Atlantic over fifty times—on direct passages between, say, Southampton and New York and on longer, port-blended trips as well. But I too like the mixture of sea days with ports of call, often at more remote, smaller places. I am fascinated to call in at, say, charming Invergordon in Scotland or pass through Greenland's spectacular Prince Christian Sound or at quaint Cornerbrook in Newfoundland. And these days, there are more opportunities than ever. Cruise line schedules are so wonderfully alluring. There are crossings from Rome to Fort Lauderdale via Barcelona, Palma, Malaga, and then St. Maarten in the Caribbean. Trips from Fort Lauderdale to Copenhagen, stopping at Nassau, Bermuda, Ponta Delgada, Le Havre, and Dover (London). An eighteen-day trip from Rotterdam to Boston with thirteen stops along the way or, for something more direct, a ten-day voyage—nonstop from Southampton to Miami. There are crossings from Galveston, Texas, to Barcelona, and

◆ ◆ Triumphant and welcomed by a serenade of whistles and horns, the *Queen Mary* arrived in New York for the first time in June 1936. ◆ The sleek style of the Deco age was used in poster advertising as well. This example is promoting French line crossings from Paris to New York. ◆ ◆ The *Queen Mary* was one of the most beloved and popular of all transatlantic liners. From 1926 until 1967, she made one thousand crossings of the Atlantic. ◆ The brilliant *United States*, shown arriving at New York for the first time in June 1952, was the last of the famed Blue Riband speed champions on the Atlantic.

from Copenhagen to Quebec City. It is so difficult to decide; I'd like to do all of them.

But, while it might be Bermuda or Belfast tomorrow, it is still about a moving city traveling between continents, fine food and service, bouillon at 11 and high tea at 4, sumptuous, multi-course dinners, floor shows and feature films, conversations at the pool and drinks before dinner, teak decks and star-filled nights, the vast expanse of the sea and the gentle, reassuring hum of the ship's engines. It is still "the only way to cross"— and long may it continue!

CROSSING THE ATLANTIC 23

THE NORTHERN ROUTE

The equator divides the Atlantic exactly in half. One can subdivide that portion lying north of latitude 0° into two, clumsily named quarters, the northern North Atlantic (rougher and colder) and the southern North Atlantic (calmer and warmer). Each feeds one of Europe's two bustling cruise arenas, the Baltic and Mediterranean seas. Though some ships switch between the two in mid-summer, most spend April through October exclusively in one. The calm, warm seas of the southern North Atlantic are separated on the west from the Caribbean by the numerous islands first explored by Columbus, and called by him "the West Indies."

Each sea boasts its own Baedeker of cultural perks: Baltic voyages embrace almost every Scandinavian capital, highlighted by an overnight stop to absorb the riches of St. Petersburg. Mediterranean ships can sample the spellbinding antiquities of Athens, Rome, or Naples; savor Venice's

✦ Bar Harbor, Maine, is a small town on Mount Desert Island that has been home to such luminaries as the Rockefellers, J. P. Morgan, and Katharine Hepburn.
✦ Dedicated on October 28, 1886, *Liberty Enlightening the World,* better known as the Statue of Liberty, remains an indelible icon for those sailing into New York harbor.
✦ The Metropolitan Museum of Art, located on the edge of New York's Central Park, is one of the largest and most important art museums in the word. The Temple of Dendur was donated to the United States in 1968 after it was dismantled by the Egyptian government to protect it from rising waters after the construction of the Aswan High Dam. It was reassembled in the Met's Sackler Wing in 1978 where it remains one of the museum's top attractions.

CROSSING THE ATLANTIC 25

→ In operation from 1892 until 1954, Ellis Island served as the United States's main immigration point. Over 12 million immigrants traveled via steamship to Ellis Island, and today, more than 40 percent of the US population can trace their ancestry through Ellis Island. → Located in New York's Rockefeller Center, Radio City Music Hall has been nicknamed the Showplace of the Nation. Opened in 1932, Radio City was the largest indoor theater in the world at the time. It features an Art Deco design similar to that used by the famous ocean liners of the era.

enchantment and the captivating Asian threshold of Istanbul. And of course visiting the numerous islands and coasts of the Caribbean practically defines the modern cruise industry.

The major cruise lines must "re-position" their ships between seasons in these seas, and bargains abound for the traveler in vacations that take advantage of the transatlantic itinerary. Since passengers must fly in one direction either before or after their transatlantic ship crossing, which direction should they choose, westbound or east?

Eastbound repositioning cruises are offered in the early spring months and typically start in New York, Florida, or Galveston, before taking in a multitude of islands en route to a European port.

Westbound repositioning cruises happen only in the late summer and fall months, so the shipboard crossing must begin with a flight to Europe.

Whereas westbound's retarded clocks produce twenty-five-hour days, eastbound's are truncated to twenty-three hours. In fact, I have found that shifting the clock in *any* direction is unsettling; either extra or deducted hours effectively discombobulate sleep.

A cogent argument favoring an eastbound sailing is that flights from America to Europe foment the most egregious jet lag. Americans will immeasurably enrich the debut of their overseas adventure by boarding a ship first. Reverse westbound passage can be more difficult as Americans typically embark the same day as their flight to Europe. A Cunard master once

suggested that he often felt he was "taking back the empties" when bringing jet-lagged Americans home to New York.

Few if any of today's repositioning crossings duplicate the line voyages of old. All are stuffed like a Christmas stocking with extra ports; so intriguing calls bracket every crossing. If one were to sail direct, the journey would be over within a week; but adding these destinations makes it a convenient, fortnightly voyage.

Since the northern North Atlantic encompasses the same waters through which most liners once plied their trade, we can begin there. Our eastbound crossing usually starts in New York with an incomparably dramatic outbound sailing past the Statue of Liberty. A couple of sea days later, the vessel may pause for a day in the mid-Atlantic, at the Azores, the chain of islands settled in 1427 by the Portuguese. Then on it presses to Lisbon (Portugal) or Le Havre (France) before finally tying up in Southampton (Great Britain).

Westbound's itinerary is richer, offering fewer sea days and more in port. Departing Southampton or Dover, we proceed, obtusely, eastward—in the very opposite direction of the New World—to Le Havre, Zeebrugge (Belgium), or even Amsterdam (Holland) before the vessel finally turns west. An alternate itinerary forsakes Continental stops altogether, calling down-Channel at British ports instead. Ireland can be coped with in two ways, either south about via Dublin and Cobh or north about, touching at Belfast, followed by a northern jog to Glasgow. An even longer northern jog brings us to Iceland's capital of Reykjavik.

From there, ambitious cruises sometimes schedule a Greenland call. (There is usually only one stop at Greenland, not counting passage through the Sound.) But however appealing the prospect of passage through Prince Christian Sound, you should be aware that the far northern seas can tend to roughness, fog, and ice so your scheduled call at Greenland may be unavoidably cancelled. But cruise lines plan for this contingency, and can make alternative landfalls.

↑ A city with a long maritime tradition, Boston was the site of the largest gathering of tall ships in the United States for Sail Boston 2000. Here the 360-foot *Dar Mlodziezy*, Poland, makes its way into Boston Harbor. ↓ Completed in 1740, Boston's Faneuil Hall is referred to as the Cradle of Liberty, due to its role as a meeting place around the time of the Revolutionary War. Sam Adams gave an impassioned speech here following the tragic Boston Massacre in 1770. → Transatlantic voyages arrive and depart from the Black Falcon Cruise Terminal in the historic city of Boston. Founded in 1630, Boston is one of the oldest cities in the United States.

One possibility is St John, Canada's easternmost landfall, three thousand miles almost due west of Cobh. After that, the vessel leapfrogs to the southwest, following North America's coastline and touching at Halifax, Bar Harbor, Portland, Gloucester, Boston, or Newport before achieving its final destination, New York.

✦ The Halifax Regional Municipality, comprised of the former cities of Halifax, Dartmouth, and Bedford, is capital of the Canadian province of Novia Scotia. In its early days, Halifax was the primary North Atlantic port for the British Royal Navy. ✦ In 1583, the area now known as St. John's was claimed by Sir Humphrey Gilbert as England's first overseas colony under the Royal Charter of Queen Elizabeth I, making it the oldest English-founded settlement in North America. Today it is the provincial capital of Newfoundland and Labrador. ✦✦ The Baddeck Lighthouse stands as a sentinel on Cape Breton Island, Nova Scotia. In 1886, inventor Alexander Graham Bell built a summer home and research laboratory near the town of Baddeck. The Alexander Graham Bell National Historic Site remains one of the area's most popular attractions.

CROSSING THE ATLANTIC

CROSSING THE ATLANTIC

CROSSING THE ATLANTIC

Also known as Godthåb (Danish for "Good Hope"), Nuuk, Greenland, is a frequent stop for transatlantic repositioning cruises. Nuuk is the first and largest city in Greenland, as well as its capital. Attractions include the Greenlandic National Museum and Archive, the Braedtet market, Santa's House, whale watching, and helicopter trips to the inland ice.

CROSSING THE ATLANTIC

✦ Located near the Arctic Circle at latitude 64°08′ N, Reykjavik, Iceland, is the northernmost national capital. The skeletal Viking ship sculpture *The Sun Voyager* by Jon Gunnar Arnason stands in Reykjavik Harbor, as an homage to Iceland's Nordic roots. ✦ Iceland's 105-foot, double-cascading Gullfoss, or "Golden Falls," were nearly destroyed by plans to build a hydroelectric plant. After a nearby farmer's daughter threatened to jump into the falls unless the plant was stopped, public outcry forced the government to instead purchase the land for a national park. ✦✦ Djúpivogur, a tiny fishing village at the head of Berufjord River in eastern Iceland, has served as a commercial port since 1589. ✦✦✦ The Blue Lagoon Geothermal Spa is one of Iceland's most popular and unique attractions. Located in the middle of a moss-covered lava bed, Blue Lagoon is a natural pool of geothermal seawater emanating from 6,000 feet below the earth's surface. ✦ Named after Icelandic poet and clergyman Hallgrímur Pétursson (1614 to 1674), Hallgrimskirkja is the tallest building in Iceland at 244 feet. This Reykjavik landmark was commissioned in 1937. The statue in front of the church of Leif Eriksson was a gift from the United States.

CROSSING THE ATLANTIC 35

⬆⬆ Started around 1290 The Akershus Fortress in Oslo, Norway, has withstood many sieges, primarily from Swedish forces, and has never been captured by a foreign enemy. Still an official military area, the castle serves as headquarters for the Norwegian armed forces intelligence; however, it is open to the public and it houses the Norwegian Armed Forces Museum and the Norwegian Resistance Museum.
⬆ Located at Bygdøy in Oslo, Norway, the Viking Ship Museum houses ancient ships from Tune, Gokstad, and Oseberg, and is part of the Museum of Cultural History. ➡ The seaport of Ålesund, Norway, was nearly destroyed by a terrible fire in 1904. The town was rebuilt in the Art Nouveau style popular in Europe at the beginning of the twentieth century.

CROSSING THE ATLANTIC

⬆ At this monument in Edinburgh stones have been laid to mark the different counties in Scotland. ➡ Originally known as St. Giles Street, named after the patron saint of the city, Edinburgh's main shopping thoroughfare was renamed Princes Street by King George III, after his two sons, Frederick, Duke of York and the Duke of Rothesay (later to become King George IV). ⬇ Situated atop Castle Rock, overlooking the city of Edinburgh, Scotland, the Edinburgh Castle is one of the most famous and most visited sites in all of Great Britain. While human habitation of the site dates back to the early Iron Age. St. Margaret's Chapel, constructed at the start of the twelfth century, is the oldest building in the castle, and in Edinburgh.

CROSSING THE ATLANTIC

CROSSING THE ATLANTIC

◆ St. Coleman's Cathedral, also know as Cobh Cathedral, is an imposing presence overlooking Cork Harbor in Cobh, Ireland. The stone foundation was laid in 1868, but it took forty-seven years to complete construction. The cathedral is one of the best examples of the nineteenth-century Gothic Revival in Ireland. ◆ Founded in 1030 by Sitriuc, King of the Dublin Norsemen, Christ's Church Cathedral is the oldest building in Dublin. The Cathedral includes the exhibition "Treasures of Christ Church" reflecting one thousand years of history, architecture, and worship in Ireland. The exhibition includes a unique range of manuscripts, historic artifacts, and spectacular examples of gold and silverware. ◆ Opened in 1816, Ha'penny Bridge (officially Wellington Bridge after the "Iron Duke," Arthur Wellesley, the First Duke of Wellington) received its popular moniker from the toll charged to cross the river.

CROSSING THE ATLANTIC

↑ **Located in Westminster, the Clock Tower and the Houses of Parliament remain popular tourist attractions in London, England. The tower at the northeastern end of the Houses of Parliament is popularly known as Big Ben, although that moniker officially refers to the clock's main bell.** → **Westminster Abbey has been the site of every coronation since 1066. Much of what visitors see today dates from the reign of King Henry III, who began rebuilding around 1245.**

◆ The White Cliffs of Dover on the English coastline face France at the narrowest point of the English Channel. The cliffs have long been a symbol of the British defenses against invasion from Continental Europe. ◆ The Pont de Normandie (Bridge of Normandy) crosses the river Seine linking Le Havre to Honfleur in Normandy, France. ◆◆ A freighter enters the Port of Le Havre. Known as La Porte Océane, Le Havre has a long tradition as a port of call for transatlantic ocean liners. ◆◆ Tintagel and the nearby Tintagel castle on the north Atlantic Coast of Cornwall have long been associated with the legend of King Arthur and the Round Table. ◆◆◆ The Port of Dover offers regular ferry service across the English Channel to France.

CROSSING THE ATLANTIC

CROSSING THE ATLANTIC 45

Repositioning journeys across the southern North Atlantic offer the same wealth of exotic landfalls. Embarking at Miami, Fort Lauderdale, or San Juan, eastbound voyagers may pause at any number of familiar Caribbean calls—St. Thomas, St. Maarten, or Barbados—before consecutive sea days begin; but their passage is essentially balmy and subtropical. Almost the same three-thousand-mile quest achieves the islands of Madeira, the capital Funchal serving as passengers' cherished first sight of Europe's sea-girt fringe. For variety, an African call at Casablanca may follow before the vessel zeroes in on the Straits of Gibraltar. Sometimes passengers go ashore there to explore the legendary fortress and its resident monkey population.

Chances are your eastbound repositioning will end in Barcelona. It is a rich destination in and of itself as well as a pivotal re-provisioning venue for the companies. Truckloads of provisions, having trekked overland from half a dozen European

THE SOUTHERN ROUTE

↑ The Andalusian city of Cadiz is one of the oldest cities in Europe, with a history dating back to 1100 B.C. when the area was believed to have been a small trading post. Throughout its history, this important port city has been under Carthaginian, Roman, and Moorish rule. During the Age of Exploration, Christopher Columbus launched his second and fourth voyages from Cadiz. ← Port Vell (the Old Port) serves as the cruise terminal of the beautiful Catalonian city of Barcelona, Spain. Located on the Mediterranian in northeastern Spain, Barcelona is the country's most cosmopolitan city as well as its most important port. → The still uncompleted Sagrada Familia (the Holy Family) is Barcelona's most popular attraction, with more than two million visitors annually. Famed Catalonian architect Antoni Gaudí devoted much of his life to the creation of this Roman Catholic basilica.

CROSSING THE ATLANTIC

distribution points, await inbound vessels on the pier, filling their storerooms for the Mediterranean programs to come.

Barcelona is as inevitable for the westbound re-positioner as is Florida for the eastbound. And, once again, duplicating the port-rich preamble prevailing to the north, retrograde cruise calls precede the crossing. Sailing eastbound, the ship drifts overnight to Monte Carlo, Villefranche, Livorno, or Naples before, like some confused but reformed homing pigeon, realigning itself westward. Malaga and Gibraltar are passed by but a final, lingering Continental call may be made at Cadiz or Lisbon before the Madeiras or Cape Verde islands. Occasionally, if too much time has not been consumed in the Mediterranean, westbound ships may go on to the Azores as well but that is more characteristic of a New York rather than Floridian destination.

So a bare necessity, the repositioning of ships spending the winter in the Caribbean and the summer in Europe, has been transformed into a popular shipboard alternative. It has become the cruise industry norm, the preferred means of carrying today's passengers comfortably back and forth across that most unpredictable ocean.

Of course, there is a splendid way to avoid the onus of a flight in either direction. Instead of booking a one-way repositioning crossing, choose a rewarding round-trip on the world's last working ocean liner. During the summer months,

← **Located on the hills just outside of Malaga on Spain's famous Costa del Sol, the village of Istan boasts steep, narrow streets of whitewashed houses with Arabic roof tiling typical of Andalusia. The village is part of Sierra de Las Nieves Natural Park, which was declared a Biosphere Reserve by UNESCO.**

→ **The Plaza del Toro (bullring) in the Andalusian port of Malaga sits in the heart of the city. Built between 1874 and 1876, this classic bullring also houses a museum dedicated to bullfighting legend Antonio Ordonez.**

Queen Mary 2 thunders back and forth across the northern North Atlantic in six uninterrupted and exhilarating days. You can either sail consecutively eastbound and westbound or take a restorative breather in the UK between crossings. For the purist crossing any portion of the North Atlantic, there is nothing superior.

◆ Located on the famed *Ruta de los Pueblos Blanchos* (Route of the White Villages), the small village of Setenil de las Bodegas in the Cadiz district is unique in that it was built out of a network of caves in the cliffs above the rio Trejo.
◆ Located on the southwest tip of the Iberian Peninsula, Gibraltar is perhaps most famous for its geological formation the Rock of Gibraltar, also sometimes referred to as the Pillar of Hercules. The inside of the Rock contains the Great Siege Tunnels, a labyrinth of fortifications built by the British starting in 1782 after France and Spain tried to capture Gibraltar during the American Revolutionary War.

← The picturesque Portuguese town of Azenhas do Mar is located on the Costa da Lisbon. Its whitewashed houses are perched on cliffs overlooking the Atlantic Ocean. ← Due to a large number of clubs and a thriving music scene, the Bairro Alto (Upper Quarter) is the heart of Lisbon's nightlife. Built on seven hills where the river Tagus flows into the Atlantic Ocean, the Portuguese capital is known for its sunny days and temperate climate as well as its rich history and culture.

↑ The Kasbah des Ouidais is a charming, quiet section of Rabat, Morocco. The Ouidais is known for its whitewashed houses with blue painted parapets. Located on the Atlantic ocean at the mouth of the river Bou Regreg, Rabat is one of Morocco's most important cities and home to the royal palace. → Completed in 1993, the King Hassan II Mosque in Casablanca, Morocco, is the second largest mosque in the world, after Masjid al-Haram in Mecca. Named in honor of a former Moroccan king, the mosque and its courtyard have room for over one hundred thousand worshipers. → → The Moroccan city of Safi is a center for fine, traditional Moroccan pottery. Aside from its small Medina, Safi's main attraction is Bab Chaâba, the Potter's Quarter. Here, at the base of Potter's Hill a wall is decorated with pieces of broken pottery.

◆ The Jardim Botanico is located on a hillside overlooking Funchal and is best known for its choreographed garden, a carpet of multi-colored plants arranged in geometric shapes and lettering. A cable car takes visitors from the gardens up to the historic village of Monte.
◆ Funchal has been the capital city of Portugal's Madeira islands for more than five centuries. During the sixteenth century, Funchal was an important port of call for ships heading to the New World. Known for its famed wine, stunning scenery, and perfect climate, Madeira is situated four hundred miles off the coast of North Africa.

◆◆ Icod de los Viños in northern Tenerife is home to a famous dragon tree *(Dracaena draco)*, which some estimate to be a thousand years old. ◆ The volcanic island of La Gomera is the second smallest of the Canary Islands off the coast of Africa. The upper part of La Gomera contains the Garajonay National Park, which is a UNESCO site with many hiking paths. ◆◆ Christopher Columbus stopped in Las Palmas de Gran Canaria in 1492 before heading across the Atlantic Ocean. The house he later built there, Casa Colon, has since been converted into a museum of the American Conquest. ◆ Tenerife, the largest of the seven Canary Islands, offers lush forests, exotic plants, volcanoes, and diverse wildlife. ◆ Known as the "Venice of the Canaries" for its canal-like channels, Puerto de Mogán is a charming fishing village and resort on the southwest coast of Gran Canaria.

CROSSING THE ATLANTIC

CROSSING THE ATLANTIC

✦ Horta, on the island of Faial in the Portugese Azores, became an intercontinental submarine cable station due to its sheltered harbor and strategic location.
✦✦ Today, tourism is the primary economic force on Faial; however, the island also raises potatoes, cereals, fruits, and cattle.
✦ La Caldeira is an extinct volcanic cone and the highest point on the island of Faial.
✦ Angra do Heroismo, in the Azores, is home to a UNESCO World Heritage Site. From the fifteenth century through the advent of the steamship, this historic port was a regular stop for ships crossing the Atlantic.

CROSSING THE ATLANTIC

✦ The Carribean island of Saint Martin is one of the smallest landmasses in the world that is divided between two nations. The southern half, Sint Maarten, is part of the Netherlands Antilles and the northern half, Saint-Martin, is part of the French overseas region of Guadeloupe.
✦ Known for its nightlife, pristine beaches, and casinos, St. Martaan/St. Martin is a major destination for cruise ships. ✦✦ Guavaberry is known as the national liquer of Sint Maarten. The guavaberry or rumberry (*Myrciaria floribunda* or *Eugenia floribunda*) is also used for medicinal purposes and to make jam.

CROSSING THE ATLANTIC 63

↑ Martinique is an overseas department of France, although its culture has a mixture of French and Caribbean influences. Most of the island's inhabitants are descendants of African slaves. Due to Martinique's status as a vacation hotspot, it enjoys a higher standard of living than most other Caribbean islands. → Grenada is the second smallest independent country in the Western Hemisphere, yet it offers ample opportunity for spectacular scenic hikes. Concord Falls, on the western coast of the island, boasts triple cascades, the lower of which is a popular swimming area, camping spot, and tourist attraction.

CROSSING THE ATLANTIC

66 CROSSING THE ATLANTIC

◆◆ Old San Juan consists of four hundred restored buildings from the Spanish Colonial period of the sixteenth and seventeenth centuries. It is also the main entry point for cruise ships arriving on the island. ◆ La Romana is the center of the Dominican Republic's booming tourist industry and is a bastion of beautiful beaches, resorts, and golf courses. ◆◆ Castillo de San Cristóbal is part of the San Juan National Historic Site and was built by the Spaniards to protect against attacks on the city of San Juan. When it was completed in 1783, the fort nearly surrounded the entire city of San Juan. ◆ "El Morro," (the promontory) or El Castillo de San Felipe del Morro, is a citadel built by the Spanish in the sixteenth century to defend the entrance to San Juan Bay. A UNESCO World Heritage Site, the fort is one of Puerto Rico's most visited attractions with more than two million visitors a year. ◆◆ The Baston de Santo Domingo is a burial ground located next to Old San Juan.

✦✦ The Bahamas is an archipelago of more than seven hundred distinct islands and cays. Home to numerous resorts, restaurants, and hotels, its stable economy is based primarily on tourism and banking. ✦✦ Conch shells, masks, and, of course, straw hats are among the many items available at Nassau's famous Straw Market in the Bahamas. ✦ Horse-drawn carriages bring an old-time feel to Bay Street in downtown Nassau. ✦ The Goombay Festival is a yearly celebration of music, dance, art, food, and Bahamian heritage. The Goombay dancers wear colorful costumes with tall headdresses and dance to the local rhythmic music with African roots.

CROSSING THE ATLANTIC 69

✦ The Port of Miami is the busiest cruise ship harbor in the world, with almost four million passengers per year. ✦✦ More than three hundred cruise ships a year visit Key West, Florida, which is also haven for sailors of a more traditional kind. ✦✦ The oldest remaining overseas British territory, the Islands of Bermuda were settled two centuries before the formation of the United Kingdom. Bermuda is one of the few places in the world that has pink sand beaches and turquoise oceans. ✦✦ Founded in 1612, the town of St. George on St. George Island in the Bahamas is one of the oldest colonial cities in the Western Hemisphere. Many historic buildings still stand as museums, restaurants, pubs, shops, and private homes. ✦✦ Because of its intricate canal system, Ft. Lauderdale, Florida, is sometimes known as the "Venice of America."

CROSSING THE ATLANTIC 71

PHOTO CREDITS

The following photographers hold copyright to their images as indicated: Ancient Art and Arch Collection/DanitaDelamont.com, 38 (top); Jon Arnold/DanitaDelamont.com, 30–31 (top), 32, 33, 36 (top), 37, 38 (bottom), 39, 40, 41 (top), 41 (bottom), 45 (bottom), 46–47 (top), 48, 51, 52, 54 (inset), 58–59 (top), 58 (top), 58 (bottom), 58–59 (bottom), 59, 64, 68 (top left), 71 (bottom); Bill Bachman/DanitaDelamont.com, 34, 35 (middle), 66–67; David Barnes/DanitaDelamont.com, 50–51, 53; Walter Bibikow/DanitaDelamont.com, 28 (top), 29, 42, 44 (inset), 45 (top), 45 (middle), 46, 47, 65, 68 (top right); Carol Cohen/DanitaDelamont.com, 44; Tom Curley/DanitaDelamont.com, 24–25 (top); David Frazier/DanitaDelamont.com, 66 (inset); Howie Garber/DanitaDelamont.com, 43; Bob Givenski/DanitaDelamont.com, 67; Greg Johnston/DanitaDelamont.com, 62, 66 (top), 68 (bottom), 69; Alison Jones/DanitaDelamont.com, 56–57, 57; Bob Krist, 24, 25, 26, 27, 28 (bottom), 35 (bottom left), 35 (top), 35 (bottom left), 35 (bottom right), 60, 61 (bottom left, 61 (bottom right), 63 (top), 63 (bottom), 70, 71 (top), 71 (middle); John & Lisa Merrill/DanitaDelamont.com, 49, 54; Monde Image/DanitaDelamont.com, 55; Michele Molinari/DanitaDelamont.com, 66 (bottom); Amos Nachoum/DanitaDelamont.com, 61 (top); Marisa Pryor/DanitaDelamont.com, 36 (bottom); Patrick J. Wall/DanitaDelamont.com, 30–31 (bottom), 31; Michele Westmoreland/ DanitaDelamont.com, 70–71.